Ramblings of a Wannabe Painter

David Zwirner Books

ekphrasis

Ramblings of a Wannabe Painter
Paul Gauguin

Edited and translated by Donatien Grau

Contents

The Last Words of the First Modern Artist

Donatien Grau

Paul Gauguin (1848–1903) occupies a unique place in the genesis of modern art: at the beginning of the twentieth century, when Marcel Duchamp, Pablo Picasso, and Francis Picabia were all beginning to paint, Gauguin served as one of the two major poles of modernity; the other was Paul Cézanne. Cézanne refused to engage with anything but his art—his painting—and eventually decided to paint only the limited life of Aix-en-Provence, the people, the place. In so doing, he became the father of one of modernity's two main lineages: that of refusing the world at large and embracing the work as a world of its own.

Gauguin did the opposite. He decided that his role as an artist went beyond evoking heightened emotions through paint; he knew that his new use of color would help expand the definition of art as a whole. Being a painter could only be achieved if painting became part of a broader set of activities that encompassed the decorative arts, sculpture, engravings, photographs, what was later to be called performance art (traveling to exotic places, embodying the figure of the artist), and even literature. It was in this expanded context that writing became important to Gauguin in the late 1890s, as he traveled, stayed abroad, and began to pen his own mythology.

Through mythology, he also transformed himself into the first multimedia artist—not simply by working in different media, as in the great ancient Greek and Italian Renaissance traditions (of Phidias and Apollodorus of Damascus, for example, and later of Leonardo da Vinci and Michelangelo), but also by using his individuality as

an artist to challenge conventions and make art a space for controversy.

Gauguin was inherently an artist in the modern sense of the word. He spent a considerable amount of energy building a persona, but the persona he created was never disconnected from the public sphere—that of politics, society, culture, and the literary and artistic worlds of his time. He questioned all of these worlds as they fell under the category of "convention," having been fixed and defined prior to the artist's intervention. The function of art, in Gauguin's system, was to open a space in which every convention could be questioned. Nietzsche's work was spreading throughout the intellectual and creative worlds of the 1890s, and his concept of the "transmutation of all values" can be considered the very principle behind Gauguin's own artistic actions: not only did the artist question sexual, political, anthropological, and cultural norms in his work, he also pushed this questioning one step further by challenging norms in his daily life.

Thus Gauguin represents a crucial link between, on the one hand, Gustave Courbet's revolutionary thinking, which manifested in the open field of politics during the Paris Commune, and, on the other, the constant questioning of identity led by Duchamp, Picabia, and Max Ernst, which happened largely outside the common political sphere. Gauguin was very much in touch with society despite having set out on the Pacific, and from a distance, he questioned its values through art. As a re-

sult, Gauguin's work became a catalyst for engaging with what we now understand to be many of the great issues in art—the role of the museum; the place of visuality in different forms of art; the relation that artists have to the political and cultural world around them. Nowhere did Gauguin address these issues as radically and as clearly as he did in "Racontars de rapin," an essay written a few months before his death, which was rejected by *Mercure de France*, the prestigious journal to which he submitted it.

The essay is part of an ensemble of writings by Gauguin that starts with a diary of his trip to Tahiti, *Noa Noa* (1893–1894), and continues with numerous essays, some of which were published in *Le Sourire* (*The Smile*), the journal he founded, edited, and to which he was the sole contributor by the late 1890s. But "Racontars de rapin" has a particular role in the geography of all these texts because it is the very last, and the bluntest. It is also the one in which Gauguin most directly expresses his views. As opposed to many of his posthumously published notes, "Racontars" is an elaborate and carefully constructed piece of writing.

Translating the title as "Ramblings of a Wannabe Painter" may seem flippant at first, but it is true to the meaning of the French: *racontars* are the sort of stories one tells over and over again, in which the issue is eventually not what is told as much as *how* it is told. A *rapin* is an apprentice-painter, a term Gauguin uses ironically here, since he was already a mythic figure during his lifetime. Calling himself an "apprentice-painter" at the end

of his life is the equivalent of calling himself a "wannabe," a striver who has not yet made it. Gauguin evidently intends for us to notice this irony. In this text, he claims a shaky identity as a painter—a "wannabe"—as if he were a writer by profession, and a painter only secondarily. The opposite, of course, was true: Gauguin was a painter through and through, and although he attempted to break into the literary world, he was never acknowledged as a writer. His relationship to the written word was that of an admirer who wanted to be published in the main literary journals of his time. He was knowledgeable, he was passionate. Writing was a side practice, and as a side practice it became an open field for reflecting on his actual calling—painting.

In keeping with his critiques of the writers of his time, Gauguin avoids an overly formal, fin-de-siècle approach; instead, he writes in lively, sometimes colloquial French. His language emerged from the people's language, and he brings to it his unique eye and extensive knowledge. Through his direct and powerful style, this major artist reveals his internal experience, and tells anyone who is ready to listen what being an artist is really all about.

The extraordinary energy of this essay makes it essential reading for anybody interested in the development of art since 1900. It is filled with details and names that are linked to the art world of Gauguin's time, but it also presents a general picture of how to be an artist in modernity—how to navigate a complex world of critics, theories, market forces; how to see things anew, and how

to innovate without giving up the important influences of the past. This is a statement from one of the very few artists who single-handedly shaped what it means to be an artist today.

Ramblings of a Wannabe Painter

Criticism is our censorship—a watching watcher! A Watcher, that's too much. Why watching? The avant-garde, by comparison, is a signaling semaphore—those who see things before others. So the enemy in view doesn't look like a friend.

And that brings in beefsteaks, badges.

Head of Fine Arts: Literati;

Inspectors of Fine Arts: Literati;

Critics: Literati;

Museum Directors or Curators: Literati;

And to accept paintings into museums—the Supreme Court, Politicians.

Let's add some truffles.

It's funny—not that funny.

Not any funnier than sending someone like Berlioz [1] to Rome to learn music.

I'm going to try to talk about painting, not as one of the Literati, but as a painter. It would be a Duty, if Duty were synonymous with freedom. But ever since a policeman in a white helmet reported me for not having a light on in my car at night, informing me—subsequently and consequently—that it was his Duty, that word has taken on a stupid and brutal meaning.

It's therefore not a Duty but a fancy. In this summary, there will be a lot about criticism, perhaps too much, but it will belong to criticism and the public to take into account the exaggerations of a turbulent mind.

I had some trouble with a horrible thing (unknown in France) called Senior Colonial Administration, and I de-

cided to fight it a bit, just for fun: I penned a mean Diary.[2]

In a café someone told me: Oh! You're lucky you didn't go to jail.

—Why? My words mean This, but they also mean That.

—Impossible, I know words all too well: I'm a Professional Typographer!

I don't want to insult anyone by saying that all the Literati are typographers, but isn't there a relationship between the typographer above and the Literati, who think they *know* painting when as thinkers the only artful thing they do is open their mouths?

Mr. Gustave Kahn,[3] a serious mind of the time, and one of the few gifted Literati, says this (issue of the *Mercure*,[4] October 1898):

> *It would be difficult to accept the excessive and never quite selfless theories, which place the efforts of critical intelligence above all other efforts.*
>
> *Understanding everything is good; connecting everything is better—creating is something, too. But one thing is certain: well-meaning criticism, considered in terms of its many obligations, requires, besides a diversity of knowledge, originality of ideas and the precious gift of analogy.*

We agree with him so far, but we begin to object the moment he says:

> *And yet, never has visual art been at once as interesting and as self-conscious in the many ways it opens up to us—never has it needed as many critics and well-informed advisors.*

Among the shrewd and well-taught critics who have taken on, despite the futility and material difficulty of the task, the charge of informing the public, helping artists, and serving them by allowing them to compare visual art with the literary arts—among those erudite writers, sensitive to beauty, aware of all of its manifestations, etc.

Either the artist is a superior man—and for that very reason completely capable of understanding his own art and comparing it to the literary arts (if that comparison is useful in the first place)—or the artist is an inferior man whom we need not take into account: a brain and a will without strength. One critic tells him: *Go north.* Another critic says: *Go south* (the same way he might say *Sit down!*)—which is the right direction?

Mr. Gustave Kahn would never argue that several critics point the same way (he's too smart for that). And if that were indeed the case, everyone would move in the same direction and art would no longer be a matter of selection.

Nor would Kahn say that these critics, despite enjoying the precious gift of analogy, know both the visual and literary arts well enough to compare them.

Visual art requires too much deep knowledge. It takes a greater artist's entire life, especially when the knowledge becomes more particular instead of more general, when it becomes individual, taking into account the specific nature of the person who made the work, the milieu in which he lives, his education. When looking at an artist's work, only the future matters; the so-called well-educated

critics are only educated in matters of the past. —And what do they remember besides names in catalogues?

However intellectually precocious he may be, however attentive he is when walking through museums, a critic can't deepen the Ancients in so little time. We who have special gifts, and whose aim it is to do just that—for whom doing so is a reason to live—we're hardly able to learn the secrets of the masters.

Does Giotto know perspective? If he does, why doesn't he use it?

We wonder why Velázquez's infant (galerie Lacazes [5]) has fake shoulders and why the head doesn't join properly ... And how good it looks. While a head by Bonnat [6] joins actual shoulders ... And how bad it looks!

Velázquez, however, stands tall despite being corrected by Carolus-Duran. [7]

The visual arts are not so easy to uncover; in order to make them speak we need to question ourselves every time we question them. A complex art if ever there was one. —There's a bit of everything in it: literature, observation, virtuosity (I won't say "skill"), gifts of the eye, music. —I'll talk about music again later.

More than anything, visual art needs to be loved a great deal.

In our time, criticism is written by men of talent, well-educated men who write consciously, selflessly, devotedly, with belief, even with emotion. But that's not new! I'll only mention two earlier examples, for the record: Taine and Saint-Victor. [8]

The first spoke of everything *but* painting (read "Essay on Criticism" by Albert Aurier[9]).

The second, more assertive, spoke mostly about painters. Marchal,[10] the great Marchal! he said. Poor painter, placed on such an immense pedestal that he became dizzy and killed himself. Has anyone heard of him today? —Millet was said to be rough, wallowing in trash, and Saint-Victor buried him in a coffin. Thank God Millet climbed back out! Still, in 1872 Millet could hardly make fifty francs for a few drawings on rue Laffitte to pay the midwife. Most likely, the sacred words of Mr. Saint-Victor were the cause of his horrid deprivation.

Don't these examples offer some food for thought? Don't they remind us—in every age—of the *possibility of making a mistake?*

Certainly, our most cautious and honest critics don't look like yesterday's critics, those of the Press, led by Albert Wolff.[11]

A crooked, largely ignorant press—

Yesterday it was Bastien-Lepage,[12]

Today it's Besnard.[13]

It's hard to say if yesterday's press or today's has been more harmful.

Yesterday's press didn't convince a soul. It supported the academy, established awards and medals, sold glory quite cheaply (all things considered). But the majority likes that sort of thing—so why should we not act accordingly, in a time when the majority rules?

It's advertisement. As Jean Rictus[14] says, "If there

were no misery, there would be no trade."

While today's Criticism! How can you tell a talented man of letters, whom everyone respects: "Sir, you are wrong (albeit well-educated, honest, and full of conviction); you're dangerous because you're backed by an elite gallery that trusts your judgment, your erudition—and because you say all these things in courteous language … and last of all, because you're talking about a person who doesn't want to respond."

We're not talking about a rag that everyone reads, one that mentions painters alongside Géraudel's pills,[15] but a serious journal, dogmatic in whatever way it wants to be.

This is autocracy (you could even say the theocracy of the typographer).

Reread one year of criticism and all you see is:

Naturalistic painting.....................then some dogma

Black	"
Gray	"
Impressionistic	"
Neo-Impressionistic or scientific	"
Symbolic	"

Etc. . . .

I could be accused of having a wild imagination …

Does anyone remember the Puvis de Chavannes banquet?[16] The cities, the corporations, the State—they were all there to speak. Mr. Brunetière[17] had registered early to represent art criticism. Everybody knows that Mr. Brunetière is a remarkable man, erudite, a writer, a logician, etc., a man to whom the elite listen. He said:

Mr. Puvis—[using the salutation "Mr." to describe Puvis was already quite funny]—Mr. Puvis, I am here to congratulate you on making great paintings of attenuated colors, without letting yourself fall into overly conspicuous colors.
It was all but enough.

I was there and I murmured.

The word "Impressionism" was not uttered, but it was there between the lines: can't you smell a dogma of clear paintings without color? Mr. Brunetière doesn't like rubies or emeralds. Only pearls! Sure, I can see the pearl, but I can also see its shell.

Perhaps Mr. Brunetière will read this. He'll smile, with disdain, and say: "Let Mr. Gauguin go study at a top university first, then we can talk." —Would he be right?

After the rule of the Sword comes the rule of the Literati. I've often read things like:

No one knew how to paint the poison of the mushroom better than him.

No one knew how to capture the fleeting grace of a woman better than him.

No one . . .

As you can see, all the seats are taken; there's nothing left for us.

Criticism teaches us how to think—we are grateful and would like to teach critics something, too. Impossible! They already know everything.

Earlier, I brought up Bastien-Lepage and Besnard on purpose because they've been presented as two touchstones of forward-thinking, modern art.

In the end, Bastien-Lepage joined forces with Albert Wolff. The latter provided the ideas; the former executed the work. Then Bastien-Lepage provided examples of their collaboration for the collection.

Bastien-Lepage died and an exhibition of his work was mounted at the same time as an exhibition of a few works by Delacroix.

"Delacroix," the great Albert Wolff said with as much method as authority, "is admirable in his sketches, but fails when he wants to finish, and in fact never made a complete work..." While: "Bastien-Lepage meticulously searched every single recess of nature."

In the case of Besnard, it's no longer Albert Wolff speaking, but an art critic whose honesty cannot be questioned, one of those Literati we enjoy reading and sometimes admire—a thousand times more dangerous than the previous Wolff on whom we have the right to spit with disgust.

He says: "Besnard is the last survivor of the great painters who understood composition. He is one of the few who really knows drawing, and in the end, the craft itself."

What right does this critic have to speak of a science? Does he know where drawing begins and where it ends? Where did he learn?

Knowing *how* to draw is not the same as drawing well. Let's examine this famous science of drawing: it's a science that every laureate of the Prix de Rome knows, even those who competed and came in last; it's a science that everyone, with no exception, can learn in a few years, like

sheep led by their shepherd Cabanel.[18] A science they learn easily, effortlessly, while frequenting pubs and brothels. I'm including biblical history here, which, naturally, allows you to make great compositions forever.

As a result, Besnard learned "The Moonlight Song"[19] and still sings it quite easily! In the beginning he performed it with white pigment and burnt sienna, then later, good dog that he is, smelling the way the winds were turning, he told himself that Impressionism by a man who knows how to draw would be quite wonderful. His starlight song went through every color of the rainbow.

A witty painter, to whom Besnard was brought up as a form of intimidation, said: "Besnard is certainly a superb bird, but why does he use our wings to fly?"

This man is celebrated and he doesn't come near Bastien-Lepage—Bastien-Lepage, whom no one speaks about anymore and who yet, before he died, claimed that he would need to forget everything in order to start again.

A painter who has never known how to draw but draws well: Renoir. I mention him because he was featured next to Besnard at Durand-Ruel (Exhibition of the Orientalists).[20]

In Renoir nothing is in its proper place: don't look for a line, it doesn't exist; as if by magic, a pretty patch of color, a caressing light, say enough. A light fuzz shimmers on cheeks, as on a peach, animated by the wind of love whispering its music into waiting ears. One would like to bite the cherry of that mouth—through the laughter a little tooth appears, sharp and white.

Beware, its bite is cruel: it is a woman's little tooth.

Divine Renoir, who doesn't know how to draw.

Based on this wise critic's principles, it's illogical to admire these two artists. He doesn't like Bouguereau,[21] fine, but he admires Claude Monet. While admiring Claude Monet, he trashes Pissarro, or at the very least tries to make him out to be a ridiculous artist.

I wonder what all this might mean in one human mind.

And if we look at Pissarro's art as a whole, in spite of its fluctuations (Vautrin [22] is always Vautrin despite his innumerable incarnations), we find not only an excessive artistic will that never deceives, but also an essentially intuitive art of the very best breed.

However far away the bale of hay up on the hill, Pissarro knows how to step aside, walk around, and take a careful look.

He has looked at everyone, you say! Why not? Everyone looked at him, too, and denies it. He was one of my masters and I won't deny it.

From him to a window, a charming fan! A simple gate, half open, separates two *very* green prairies (Pissarro green) and allows a herd of wide-eyed geese to walk by, wondering, worried: "Are we going to Seurat's prairie or Millet's?" Finally they all go to Pissarro!

This "Pissarro green" gets a nice description from the witty D: "Have you seen," he says, "Pissarro's gouaches? Peasant girls on the market selling green vegetables. They look like little virgins delivering poison."

See, Mr. Critic, Pissarro is a virgin who had many chil-

dren and remained a virgin despite the seductions of money and power.

He's Jewish! That's true.

But today there are so many honest Jews who are also superior men.

You don't pretend to have discovered Cézanne. Today you admire him.

While admiring him (which requires understanding) you say: "Cézanne is monochromatic."

You could have said polychromatic, and even polyphonic.

—From the eye and the ear!

Cézanne does not come from anyone; he is content with being Cézanne. There's a mistake, otherwise he wouldn't be the painter he is. He isn't like Loti,[23] who never read Virgil; and he has looked at Rembrandt and Poussin with eyes that understand what they see.

Apples, Rembrandt?

Yes, Rembrandt, apples.

I have so much to say on this subject but I don't want to bore the reader (whom I'm taking considerable advantage of at the moment, carried away by my admiration for some and my hatred of others).

By the time he was taken for military service, Péladan[24] had already read several thousand books. Some time ago, he also tackled another dogmatic style (Christian mystical painting).

You celebrate Burne-Jones[25]—I'll give a little more ground to him, for two reasons. First, because he's a for-

eigner; second, because even though he's not a master, he's an artist of some merit who was looking for art and not just for money.

He seems to be a sad Englishman, suffering from melancholy, traveling to Italy in order to heal himself. Italy, as it warmed him up, gave him back his life and he fell for beautiful Italian art. But as an Englishman, and particularly a modern Englishman, how could he ever become Italian?

Italians are not tender and don't get along well with sentimental people. And there are so many different schools, from the Florentine to the Lombard primitives, squat and heavy like the Dutch. It's too much for a melancholy man to bear.

With no victory in sight, Burne-Jones is torn between the warm sun of Italy and the fog of England—the dreams born in the fog are cleared away under the Italian sun, and nothing remains but pale-colored spiritualism.

Sentimental sketches abandoned for lack of fortitude. I see noble instincts, noble attitudes, and I respect them, but they can't teach me anything, nor lead me to any kind of mastery.

Speaking of an Englishman, look at Whistler, the American. Paris was an education for him: he knows what Courbet, Degas, or Manet have done. But it was only ever an education, a suggestion, because he's English and proud like a Lord. Whistler's butterfly is a nearly invisible signature; even on a bare shoulder painted by Besnard it would be ridiculous. Yes, that is a master.

A bit further along, our dear Critic gives advice (in a scholar's voice): "Beware," he says to Carrière,[26] "one step further and you'll stumble into obscurity. And yet, we loved you, we admired you. These things are nothing more than apparitions, almost impossible to see."

I don't know, and I don't need to know, what happens in Carrière's soul. His soul belongs to him. Perhaps Carrière grew tired of speaking to deaf people, and only wants to speak to his followers, telling them: "Seal everything I present to you." I'll be one of those followers.

Perhaps now that he has become more a master of himself, he speaks with even greater simplicity.

His Belleville Theater[27] does not allow us to see the actors, yet I can hear them. Rembrandt's chiaroscuro: obscure ... But he's drowning. Don't worry. Carrière is swimming between two bodies of water. In any case, the rod you're handing him is too weak, good for catching gudgeons at best.

People tell me I'm not Rembrandt, Michelangelo, Puvis de Chavannes—but I already know that! Why tell me?

Doesn't it seem like they're all jumbled together. And is our Critic a Rembrandt, a Michelangelo, a Puvis de Chavannes?

Jean Dolent,[28] who doesn't like lengthiness, says only a few words: "Who concedes himself to immortality does not grant immortality one minute."

Twenty years ago or so, Puvis de Chavannes's *Poor Fisherman* and *Prodigal Son* gathered dust at Durand-Ruel's,[29] rue de la Paix, without selling, even at modest prices.

The head was too big, the muscles weren't there, the trousers were empty. The little woman was ridiculous, the child was a fetus, the flowers were foul. All that in berry cream. At the time, cautious Mr. Brunetière didn't say a word.

What did human intelligence do at the time? And why has it suddenly awakened to the work today? In every period the trains are late—that should be taken as a serious warning.

Another thing that's important (in Criticism only) is the ongoing search for kinship-kingship among artists. At an exhibition in London, a clever critic wrote: "Mr. Degas seems to us to be a good student of Nittis!" [30]

Isn't this the same manic habit that the specialists have, bickering in court over the origin of their ideas? And this manic habit spreads to painters, too, who care for their originality like women for their beauty.

And then it becomes so easy to say: "Oh, you know, so-and-so is harvesting the fruit of my research. He stole everything from me and now I've got nothing!"

Like Daudet's tambourine player, this occurred to me while listening to the nightingale sing.

No, a thousand times *no*—the artist is not born in one piece. If he adds a link to the preexisting chain, that's a lot.

Ideas! Who knows where they come from? Genius, said a doctor in the *Revue blanche*, [31] might be a race that tends to disappear, flattened out by modern civilization.

A man kills; the forensic pathologist says he wasn't drunk. He wasn't … but maybe his father was.

Ideas are like the dreams of a more or less formed assemblage of things or thoughts half-seen—do we really know where they come from?

I borrow again from Jean Dolent (may he forgive me!), when he says:

Transposing everything in order to be able to say everything, and borrowing from all models without treason or insult: the gesture of a friend, the face of a friend.

And the artist can be recognized by the quality of his transpositions. Transposing reality doesn't mean changing the color of the garters ...

I make a portrait of a woman. I like the dress. I don't like the face. I use another one instead. The first model is furious and accuses me of giving another woman a dress that belonged to her.

The point is that there are several ways of understanding theft. In my case (a bit troubled as I am by all the fathers people tell me I have) I've been tempted to say: "Fathers! I have more than you." To have inherited from so many fathers and be so poor. Not prolific enough, I've been given no children of my own.

Who cares? The work of art is made only to be made.

Alexandre Dumas was no Ibsen, but he was much more amusing. Wasn't it Henri de Régnier[32] who said that Ibsen was as boring as a schoolteacher?

Alexandre Dumas is a great mediocre. Not everyone can be a great mediocre.

Would anyone reproach him his success? I don't think the great minds would be jealous.

Speaking of Alexandre Dumas, I would like to add that it's difficult to measure the human brain the same way we measure alcohol.

I seem to be drifting off topic: don't be misled! I read what people write. Reading in the wild woods is not the same as reading in Paris.

Reading from afar, I was surprised to see that the Literati turned down Rodin's *Balzac* [33] (a statue I haven't seen and can't judge). But Rodin, if not the greatest sculptor, is at least one of the rare great sculptors of our time—turned down by the Literati! It's more frightening than the catastrophe of Martinique. [34] Has Rodin forgotten to consult the Critics in order to draw a proper connection between the literary and visual arts?

Berlioz wrote music criticism. But some would say that Painting is not music.

Perhaps there's an analogy. I would still argue that in terms of color alone, a poem needs to be more musical than literary.

Jean Dolent (him again, this time he's going to get angry, but I know how he indulges me), Jean Dolent, the Art Lover who knows so much without making it obvious, seems to understand this, too, when he says: "Harmonies that the *immediate* neighborhood can't explain." He doesn't reveal his secrets easily—the artist with sealed lips.

What did Delacroix mean, much earlier, when he spoke of the music of the picture?

Don't be mistaken, Bonnard, Vuillard, Sérusier [35]—to mention a few young people—are musicians, and you

should trust that painting is entering a musical phase.

Cézanne, to cite a senior figure, seems to be a student of César Franck;[36] he plays the organ constantly (which is why I said he was polyphonic).

To end with something that concerns criticism directly, I want to talk about literary work.

Talking about it does not mean critiquing it. I wouldn't know how, since I'm not a Professional Typographer.

In *The War of the Worlds*[37] the monsters—the Martians—don't scare me at all, and I enjoy following the Heat-Ray in its different stages, wiping out the English artillerymen as if they were mere toys. But where I am moved, despite the burlesque particular to the English bourgeois, is during the escape amid terrible panic.

But I prefer Wells's "A Story of the Stone Age."[38] Here, love means something very distant from criticism. To be an honest critic, one must not love. I like it better, I said, because, at the precise moment when I'm reading it, the author addresses only me—me alone.

That's when my entire nature, my instincts, the life that I lead come and help the author move me.

Wells's Ugh-lomi, his Eudena, I know them. I might be the only person who could paint their portrait better than it was conceived in the author's imagination.

I know that patience—specific to the savage—when he's waiting, immobile, for the right moment to jump on the bear's back. I spring with him. His bravery is exclusively in the word. He thinks of killing the bear like a hunter kills a rabbit. I saw him build his stone ax with

artfully arranged ligatures. And what's delicious about this book is the Idyll that emerges—from one extreme to the other—pure of any vice, and you might even say, of sensuality, too.

They like each other, he and Eudena, without knowing it, as one of the instinctive duties of animality. They don't speak, but both of them act on the same thought. That love—I know it.

This is to say: our emotions before a work of art or while reading a book are closely related to things distant from our understanding, which is why a mother would never find her own child ugly, for example.

This is also to say that that if a critic wants to accomplish the actual work of criticism, he needs to be aware of himself most of all, instead of trying to find himself in the work.

I have a bush neighbor, an old man that death seems to have overlooked. His tattoos and his emaciated body make him frightening. He was found guilty some time ago of cannibalism, but he was allowed to return before his sentence had run out. An Italian captain—a joker who wanted the best for me—told him I was the almighty man who had interceded on his behalf; I didn't deny it, and the lie proved very useful to me since the old man, whom no one could ever baptize, remained a sorcerer. He placed a Taboo on my person and my house—which is to say, he made me sacred.

Even though they have learned from missionaries all the superstitions these religious people teach them, they still keep to their old traditions.

This old man and I are friends and I give him tobacco without surprising him. Sometimes I ask if human flesh is good; it's then that his face lights up with infinite sweetness (the sweetness specific to savages) and he shows me his formidable fangs. I was once curious and gave him a box of sardines; it didn't take long. He opened the box with his teeth (without hurting himself) and ate it all, from top to bottom.

As you can see, the more I age the less I civilize myself.

Life begins to take on a completely different meaning. If our shifting dispositions have a great influence on our readings, they also have an influence on our work, in an even more profound way.

One more story, it will be my last. From the moment of my arrival in Fatuiva,[39] my simple bamboo hut; a slight clearing in the bush; a path.

The sun had already disappeared, leaving its red reflection on the mountain. Sitting on a rock I smoked a cigarette, thinking about who knows what, or rather thinking about nothing, as people do when they're tired.

In front of me the bush opened slightly, allowing a formless being to emerge, preceded by a stick it was using to guide it. Walking slowly, ass skimming the ground, it moved toward me.

I don't know if it was fear or something else, but I froze, and speechless I somehow held my breath. These few minutes felt like a quarter of an hour. Then I grabbed the prodding stick and uttered a "Whoo" that came out as a slightly plaintiff sigh.

I was eventually able to make out a completely naked body, skinny, emaciated, covered in tattoos (which made it look like a toad).

Without a word, this woman examined me with her hand. I first felt it on my face and then on my body (I was naked too, only a pareo around my waist): a dusty, cold hand—a coldness specific to reptiles. A terrifying sensation of disgust. Once it reached my navel, the hand opened the towel and carefully palpated my member. *Pupa!* (European), she claimed with a moan, then left toward the bush on the far side, always in the same position.

I should explain that once they reach adulthood male natives are subject (in the guise of circumcision) to an actual mutilation that leaves an enormous bulge of flesh like a scar, quite well suited to certain delicious moments.

The next day I asked and was told that for a long time the blind madwoman had been living in the bush, feeding off the remains of swine. God in his infinite beneficence allowed her to live. She was, incidentally, aware of the hours of day and night, and refused to wear any clothing on her body except a garland of flowers that she knew how to make herself. She tore everything else to pieces.

For two months, this remained a haunting vision and despite my best efforts, all my work at the easel took on a pregnant quality. Everything around me took on a barbaric, savage, ferocious aspect—rough art of the Papuan.

What I would like to say is this: in any person who creates paintings there are Emotions that can't be made concrete to the public. At most, they are pale reflections of a

mystery. In the visual arts, the intelligence of the author, however abstract it may be, is submitted for judgment, but not his Emotions! The inkbottle ... the emotions of the painter or sculptor, of the musician, are of an entirely different nature from those of the writer. They depend on sight, the ear, his entire instinctive nature and its struggle against matter.

He is a composer and a virtuoso.

And the painter from the East told his disciples:

Do not work too much after you finish; you will cool the lava of boiling blood, you will make stone of it. Even if it is a ruby, throw it far away.

IN THE NINETEENTH CENTURY

In the wake of the Revolution, the art of the eighteenth century ceased to be alive. Then, many years of destruction, soldiers, Civil Administration. For a while, there was a complete standstill in the arts; cranial activity moved to other things.

I wouldn't want to besmirch the great new lords and generals who rose from the bottom and have for many come to represent French glory, but it's obvious that these great lords—and the nation in general—were sensitive only to politics and the motherland.

Napoleon I is thought to have reconstituted everything, including art—but as a code. It wasn't the painter anymore but the teacher.

This system created good schools, schools where you could always find a plaster statue of David (just like the presidents of the Republic in our public monuments).[40]

Art was not a language anymore, as it used to be in every country with a memory of beautiful traditions, but a kind of Volapük made according to recipes.

It was also a ferule.

There was no longer any way to cut the line and jump ahead. Drawing classes according to ancient models, anatomy, perspective, history classes, etc.

A unique language.

When the State gets involved, it does things well. From all sides: it graduates teachers guaranteeing perfect and incredible mediocrity.

This Volapük is not only still spoken, it's the law! What can we do with such a language, such wild gibberish? It's convenient for mediocre people but a terrible torment for men of genius.

Among others, there was Delacroix, always fighting with the school and his temper. How to marry his squalid drawing to such a beautiful fiancée—the color he had gotten a glimpse of? That's where the sentence they repeat at the School of Fine Arts came from: "Delacroix is a great colorist but he cannot draw."

Alongside him, Ingres—voluntarily obstinate, likewise aware of the incoherence of such a language—began to

rebuild a logical and beautiful language for his own use, one eye on Greece and the other on nature.

As in Ingres, drawing was line alone—the change went unnoticed but the shift was considerable. No one around him understood it, not even his student Flandrin,[41] who never spoke anything other than Volapük, and who, for that very reason, was considered the master while Ingres was relegated to the back, until he returned in full light.

Ingres and Cimabue have things in common: among others, a sense of ridicule, that beautiful sense of ridicule, which might prompt us to say: "There's nothing closer to a masterpiece than a bad picture." And vice versa.

Because of his ridicule, Cimabue's virgins are closer to this phenomenon turned into a dogma—Jesus born from a virgin and the Holy Spirit—than any other vulgarly virginal maiden.

The painter uses a model to make the legend: the attributes, the symbols that this model holds in hand, do not reveal the legend, but the style. Or it's a trick to make us believe that it happened. —That's where the drawing has nuances, moving from the possible to the impossible. —One God, several Gods, are made in the image of mankind: that's fine. But there's something else, something interior, something that isn't on the outside.

A shoulder, a furious Ingres used to tell his students, is not a tortoise shell. Anatomy is an old acquaintance, but not a friend.

Despite his official position, Ingres was certainly the most misunderstood in his time; perhaps for that very

reason he was official. The revolutionary, the rebuilder in him, remained invisible; and for that very reason no one in the School followed him.

Ingres died, probably badly buried since today he's standing again, not as an Official but as an outsider. He could never be a man of the majority.

Thank God there was Corot, Daumier, Courbet, Manet, Degas, Puvis de Chavannes, and a few others.

After the events of 1870 the return to the Salon was formidable … in number.

Soldiers full of hate at their defeat by Prussia, and proud of their dreadful reprisals of the Commune. The great Bonnat was the painter of tiny Thiers,[42] with serenity, without shame.

After Thiers, Mac-Mahon,[43] the killer of cuirassiers, took control of the troops. Greet him, French painters, here is your leader, shouting: "Attention. Forward march!"

And everybody followed in his footsteps. After him Meissonier,[44] the Colonel of the National Guard, also shouted: "Forward march." —Meissonier, the painter of these hordes of fire where everything was clad in iron but the cuirasses.

Everybody got involved: the State, on the one hand, with all its fake luxury, its decorations, and its acquisitions.

The dream of a lavish Salon wall.

On the other hand the Press and the big banks—speculation. Then, too, the great number of artists and the influence of women. Not everyone can be a pimp.

With Zola came trivial naturalism and pornography—

pornography with innuendo. So many portraits of naked women looking like infamous harlots. The half-nude.

In the spirit of journalism, paintings became news, jokes, serials.

With photography, the promptitude, the facility, and the accuracy of drawing.

Again, Ingres is flat on his back.

This accuracy, this math—Sincerity, someone says, believing in the superlative:

Bouguereau = −100.

That's wrong: one should say: Bouguereau = 0.

Mathematically, two pounds of green are greener than one pound.

So therefore, two hundred thousand pounds of nature's green correspond on your tiny canvas, proportionally, to a milligram of green.

Here is what mathematics leads us to.

In order to be noticed in the Salon you either needed a microscopic canvas or an immense cloth.

The Trojan War sculpted in a nut (Meissonier's style) or *Ubu's Death* (Cormon's style).[45]

In Cormon's *Stone Age*, the bones of the characters are made of stone; a sure way to recognize the time in which one belongs. As in *La belle Hélène*, the oracles are tricksters.[46]

Here—in summary—is where art stood twenty-five years ago, despite certain exceptions:

A vast jail, but also an unshakable sibling.

In Saint-Denis, kings have their tombs.

Painters have the Luxembourg.[47]

In just a few years the donors—inspectors with permission from the Heads of Fine Arts and the Supreme Court—introduced Daumier, Puvis de Chavannes, Manet, and works from the Caillebotte collection.[48] I understand their good intentions but I don't approve.

The Luxembourg is a whorehouse. What they intended to do (since they were overcome with shame) was to cover up the ugly stain. In reality, they needed to destroy it from top to bottom, not bring honest people in.

Or perhaps (quite likely) they wanted to honor honest, unknown people.

What a funny way to honor someone. To lead honest girls into the brothel and tell them: "You are now in the service of the public under the direction of the woman of the house and the deputy-mistress."

I know that in cemeteries neighbors don't matter that much, but for the living . . . they do.

When it becomes interesting, when it becomes a page in the book of end-of-the-century art history—that's when someone enters the Pantheon.

Probably without knowing it, the State placed all their official bigwigs in front of one man. Everything critics could say, everything I just said, becomes useless when you're at the Pantheon. Attila's hordes, defeated and charmed by little Geneviève, are not in the painting: the painters themselves are the Barbarians. Saint Geneviève is Puvis de Chavannes chasing them away from Paris forever.[49]

There is no lesson for painters and critics more beautiful than this.

I can't guarantee it, but I believe 1872 [50] marked the first exhibition of a small group of painters now called the Impressionists. Where did these Bohemians come from? Wolves certainly, as they wore no garlands.

Though almost classical and quite simple, their paintings seemed odd: no one was ever able to determine why.

And then a burst of laughter. No, it wasn't serious: an escapade, just for fun. A few specialists in psychosis were brought in. They didn't dare give their opinion on madness; this case had not been foreseen. A few oculists, however uncertain, leaned toward Daltonism.

But it *was* serious, and the Salon didn't suspect it or it would have opened its doors wide, drowning the whole movement in numbers, shutting them up (*perhaps*) by throwing them a bone.

I said: (*perhaps*).

At any rate, the official Salon didn't see any reason to worry and then it became serious—very serious.

I won't tell their story: everybody knows it.

I only mention it to bring up one of the great and influential efforts made in France by a few—their only force, talent—against a formidable power: the State, the Press, and Money.

But in the end it was only the triumph of a certain style of painting, now more or less in the public domain, exploited by foreigners: a few dealers, a few collector-speculators.

And it was also a school (a school once again, with all the slavery it induces).

One more dogma.

Some liked them, since the Neo-Impressionists came next, trying another dogma, perhaps more terrible since it's scientific and leads straight to Color Photography.

I'm talking about dogma and not the Neo-Impressionist painters (who are very talented).

They should remember that the system is not what constitutes their genius.

It was therefore necessary—while taking into account the efforts and all the research, some scientific—to consider complete liberation, to break panes at the risk of cutting one's finger. It belonged to the next generation, finally independent and free of constraints, to find a fitting solution to the problem.

I'm not saying solve it *definitively*, since it's precisely an endless kind of art that I'm interested in, rich in all sorts of techniques, suitable for translating all the emotions of nature and humanity, of making itself appropriate to every personality, to every time, to joy, and to suffering.

For that, one has to give oneself over fully to the fight, to fight against all schools (with no distinction), not by denigrating them, but by other means—by confronting not only the official School, but also the Impressionists, the Neo-Impressionists; the old audience and the new.

Not having a wife and children who can disown you, insults don't matter. Misery doesn't matter. All that, as human conduct. As work.

A method. Contradictions, if need be.

Taking on the most powerful abstractions.

Doing everything that is forbidden, and rebuilding more or less happily without fear of excess—with excess even.

Learning again, and once one knows, learning still; defeating all the little fears, whatever embarrassment may result from them.

In front of the easel, the painter is a slave neither of the past, nor of the present; neither of nature, nor of his neighbor.

Him, him again, always him.

In the kaleidoscope, many wise things.

You shake it and it gives you a wise figure or a mad figure, or much madness. You shake it and you have an image, mad or wise.

The efforts I'm talking about were made roughly twenty years ago, secretly, in a state of ignorance, but resolutely; then it all grew stronger.

Let every man give himself credit for the birth of the work! It doesn't matter.

What matters is what exists today and will open the way for art in the twentieth century.

Nothing comes by chance.

It isn't by chance that between the floundering of Officialdom on the one hand—the desire to be half-modern, the calls for help from those whom we had previously disowned—and a few open-air schools on the other (if you wish), there appeared a new generation, surprising

for its intelligence, its varied art. Every day it seems to be solving all the problems no one ever considered.

The Bastille, which scared everyone off, has been demolished; and the open air is good to breathe.

Every door was open to them; they were welcomed from the very beginning of their careers.

Today, boldness isn't a blackball anymore; snobbery is. Every ridiculous barrier has been overcome.

Artists pick the day, the time, the room for the exhibition of their work … freely! And there's no jury.

Mac-Mahon is not there anymore to say "Forward march!" and he has been replaced by educated admirers of art. It's more encouraging, nobler, too, than a medal of honor.

Summarizing the work of the second half of the nineteenth century, I'll mention a few names among the most important:

Corot, Daumier, Rousseau, Millet, Courbet, Degas, Puvis de Chavannes, Fantin-Latour, Cazin, Gustave Moreau, Carrière.

The Impressionists: Caillebotte, Renoir, Claude Monet, Pissarro, Guillaumin, Berthe Morisot, Miss Cassatt, Sisley, Cézanne.

The Neo-Impressionists: Seurat, Signac, Angrand, Luce, Rysselberghe.

Anquetin, Bonnard, Vuillard, Roussel, Ranson, Maillol, Daniel, Filiger, Séguin, Maurice Denis, De Groux, Odilon Redon, Sérusier, Toulouse-Lautrec, Van Gogh.

Many others I forget.

Many more, arisen since I left, whom I do not know.

Here it seems to me there is enough to console us for two lost provinces,[51] since with them we have conquered the whole of Europe, and most importantly, in recent times, have created freedom for the visual arts. It's time for me to send you my regards.

September 1902, Atuana [52]

1 The radical musician Hector Berlioz (1803–1869) sojourned in Rome in 1831–1832 as a Prix de Rome fellow with the very traditional Académie de France.

2 The so-called "mean Diary" is *Noa Noa*, the account of Gauguin's first trip to Tahiti in 1891–1893.

3 Gustave Kahn (1859–1936) was a leading Symbolist poet and a very influential art critic. He was a frequent contributor to *Mercure de France*.

4 The *Mercure de France* was a journal founded in 1890 by Alfred Vallette. Alongside the *Revue blanche*, it was the Symbolist movement's main publication.

5 Louis La Caze, or Lacazes (1798–1869), was one of the most eminent art collectors in nineteenth-century Paris. In 1869, he donated 583 major works to the Louvre.

6 Léon Bonnat (1833–1922) was a well-established and successful society painter.

7 Charles-Auguste-Émile Durand (1837–1917), known as Carolus-Duran, was one of the most successful society painters during the later part of the nineteenth century. Alongside Manet, he is credited with reviving Velázquez's fame.

8 Paul de Saint-Victor (1827–1881) was a conservative critic and essayist. In 1870, he was appointed Inspector General of Fine Arts.

9 Gabriel-Albert Aurier (1865–1892) was an influential Symbolist and a co-founder of *Mercure de France*. Through that journal, he was one of the first to write about Gauguin's work, and he wrote the first published article on Vincent Van Gogh.

10 Charles Marchal (1825–1877) was a genre painter. He committed suicide after going blind.

11 Albert Wolff (1835–1891) was an art and theater critic. As the chief art critic for *Le Figaro* and editor of the newspaper, he championed academic painting and opposed Impressionism.

12 Jules Bastien-Lepage (1848–1884) was a naturalist painter.

13 Albert Besnard (1849–1934) was a very successful academic and society painter.

14 Gabriel Randon de Saint-Amand (1867–1933), known as Jehan Rictus, was a poet who started off as a Symbolist but gained fame for writing in the popular language of his time.

15 Pharmacist Auguste-Arthur Géraudel (1841–1906) developed a commercially successful pill to treat the common cold. His pills were advertised prominently in the late nineteenth-century press.

16 In 1895, the city of Paris threw a banquet celebrating Pierre Puvis de Chavannes. Over 550 artists, critics, writers, and art lovers attended.

17 Ferdinand Brunetière (1849–1906) was a professor at the Sorbonne and a member of the Académie française. He was one of the most eminent literary critics and scholars of his time.

18 Alexandre Cabanel (1823–1889) was one of the most prominent academic painters of his time. His *Birth of Venus* was exhibited at the 1863 Salon and is now held at the Musée d'Orsay in Paris.

19 "Au clair de la lune" (The Moonlight Song) is a traditional French song, popular from the late eighteenth century onwards. It is still sung to children.

20 Every year from 1893 to 1948, the Société des peintres orientalistes français (Society of French Orientalist Painters) organized a salon, which initially took place at the Palais de l'Industrie on the Champs-Élysées.

21 William Bouguereau (1825–1905) was a very successful academic and society painter. His works were widely collected abroad, notably in America.

22 Vautrin is a character from Balzac's *Comédie humaine* (*The Human Comedy*), published between 1829 and 1850, one of the monuments of nineteenth-century literature. Vautrin appears in several of the author's novels, every time in a new situation.

23 Julien Viaud (1850–1923), known by his pen name Pierre Loti, was a naval officer and a writer who traveled the globe and wrote many novels based on his experiences, particularly about Turkey (*Aziyadé*, 1879) and Tahiti (*Le Mariage de Loti*, 1882).

24 Joseph Péladan (1858–1918), known as Le Sâr Mérodack Joséphin Péladan, was an occultist and writer. He was a founder of the Salon de la Rose-Croix, which he organized at the galerie Durand-Ruel in 1892, drawing a large crowd of artists and art followers.

25 Sir Edward Burne-Jones (1833–1898) was one of the main protagonists in the Pre-Raphaelite brotherhood. His art changed noticeably after his second trip to Italy in 1862.

26 Eugène Carrière (1849–1906) was a student of Cabanel and a Symbolist artist. He was a friend of Charles Morice, Gauguin's collaborator on *Noa Noa*. Morice wrote extensively on both Gauguin and Carrière.

27 In the 1860s, Paris expanded to include the bordering village of Belleville, which then became a working-class neighborhood. It had three theaters, including the Belleville, which was active from 1828 until 1962, and was where many artists made their debuts.

28 Charles-Antoine Fournier (1835–1909), known by his pen name Jean Dolent, was an art critic and writer. He lived in Belleville, where he also held a salon that was popular among his Symbolist friends, including Gauguin, Carrière, Rodin, and Gustave Kahn, to name a few.

29 Paul Durand-Ruel (1831–1922) was one of the main art dealers to work intensely with Gauguin, as well as with Impressionist and Post-Impressionist artists, including Cassatt, Degas, Manet, Monet, Pissarro, Renoir, and Sisley.

30 Giuseppe De Nittis (1846–1884) was a painter. A friend of Meissonier as well as of Degas, he was considered a realist and participated in the first Impressionist exhibition in 1874.

31 The *Revue blanche*, founded in 1889 by the Natanson brothers, was one of the main Symbolist publications until its closure in 1903. It brought together art, literature, and politics. From 1896 to 1903 it was edited by the prominent art critic Félix Fénéon.

32 Henri de Régnier (1864–1936) was an eminent writer and poet. A follower of Mallarmé, he was the son-in-law of Parnassian poet José-Maria de Heredia.

33 In 1891, the writer Émile Zola, then President of the Société des gens de lettres, commissioned Rodin to create a monument to Balzac. After six years of waiting, Rodin proposed a revolutionary rendering of Balzac—one without any of the author's usual attributes. This created considerable public debate, and Rodin's commission was ultimately rescinded and the assignment given to sculptor Alexandre Falguière.

34 In 1891, four years after Gauguin's trip, a cyclone hit Martinique, leaving four hundred people dead and twelve hundred wounded.

35 Paul Sérusier (1864–1927) was a leading Post-Impressionist painter. A student of Gauguin, he was a cofounder of the Nabi group with Bonnard, Denis, and Vuillard.

36 César Franck (1822–1890) was one of the main musical composers of his time. He exerted a great influence on chamber music.

37 H. G. Wells's *The War of the Worlds*, first published in 1898, was translated into French by Henry-David Davray (with *Mercure de France*) in 1899.

38 H. G. Wells's "A Story of the Stone Age" follows a caveman named Ugh-lomi, who falls for a young woman named Eudena. Ugh-lomi is described as the first man to ride a horse and make a real ax. The story was translated into French in 1900 as "Récits de l'âge de pierre"—a title that echoes one of Cormon's paintings (see note 45).

39 Fatuiva—today known as Fatu Hiva—is the most isolated island in the Marquesas in French Polynesia.

40 Jacques-Louis David (1748–1825) was the leading proponent of neoclassical art, which played a crucial role in nineteenth-century aesthetics from Ingres to academic painting.

41 Hippolyte Flandrin (1809–1864) was a student of Ingres and a prominent figure in the neoclassical trend of the 1830s and 1840s. He remained popular until his death in Rome.

42 Adolphe Thiers (1797–1877) was a lawyer, historian, writer, and politician. He served as France's president between 1870 and 1872 after the Franco-Prussian War, and after the fall of the Second Empire he established the Republic as a regime.

43 Marshal Patrice de Mac-Mahon (1808–1893) was a military leader. He was elected president of the French Republic in 1873. A conservative politician, he refused to reestablish the monarchy, which would have imposed an authoritarian and clerical regime, and subsequently resigned in 1879.

44 Ernest Meissonier (1815–1891) was a very popular painter who specialized in military scenes.

45 Fernand-Anne Piestre (1845–1924), known as Fernand Cormon, was a history and genre painter. *Âge de pierre* (1884) was acquired for the French state collection and is now at the Musée d'Archéologie nationale et Domaine national de Saint-Germain-en-Laye.

46 In Jacques Offenbach's very popular opéra bouffe *La belle Hélène* (1864), the oracle Tiresias is depicted as a joker and a trickster.

47 The Musée des artistes vivants (Museum of Living Artists) opened in the Luxembourg Gardens in Paris in 1818. It was the first museum devoted to the presentation of contemporary art, and it remained active until 1937.

48 Impressionist painter Gustave Caillebotte (1848–1894) was a major patron of his peers. Following his death in 1894, his collection of sixty-eight Impressionist masterpieces was donated to the French state, which accepted two-thirds of the bequest and agreed to show them. This marked the acceptance of the Impressionists into the official narrative of art history. The Caillebotte bequest was exhibited two years later at the Musée du Luxembourg.

49 Saint Geneviève is the patron saint of Paris. She convinced the inhabitants of Paris not to surrender to the Huns during the siege of the city in 451 AD.

50 The actual date of the first Impressionist exhibition at Nadar's studio was 1874.

51 In 1871, the Franco-Prussian War was brought to an end by the Treaty of Versailles, which granted the provinces of Alsace and Lorraine to the newly founded German empire. In French nationalist discourse at the time, Alsace and Lorraine were referred to as the "lost provinces" or "lost sisters."

52 Atuana is the island in the Marquesas where Gauguin died in May 1903.

PAUL GAUGUIN (1848–1903) is one of the most significant French artists of the late nineteenth century, widely recognized for his contributions to Post-Impressionism. Gauguin's work is held in museum collections worldwide, and his notebooks and travel journals have been published and translated into many languages.

DR. DONATIEN GRAU is a scholar and guest curator at the Getty Museum, Los Angeles. He holds doctoral degrees from the Université Paris-Sorbonne and the University of Oxford. An editor-at-large of *Purple Fashion* magazine, a contributing editor of *Flash Art International*, he is the author of numerous essays on modern and contemporary art. Twice a guest researcher at the Getty Research Institute, he has dedicated a significant part of his scholarly research to the late nineteenth- and early twentieth-century literary and artistic moment. He also serves as the advisor to couturier Azzedine Alaïa, in charge of his not-for-profit exhibition space in Paris, the Galerie Azzedine Alaïa.

"Ekphrasis" is traditionally defined as the literary representation of a work of visual art. One of the oldest forms of writing, its meaning originated in ancient Greece, where it referred to the practice and skill of describing people, objects, and experiences through vivid, highly detailed accounts. Today, ekphrasis is more openly interpreted as one art form, whether it be writing, visual art, music, or film, being used to define and describe another art form, in order to bring to the audience the experiential and visceral impact of the subject.

By bringing back into print important but overlooked books—often pieces by established artists and authors—and by commissioning emerging writers, philosophers, and artists to write freely on visual culture, David Zwirner Books aims to encourage a richer conversation between the worlds of literary and visual art. With an emphasis on writing that isn't academic in the traditional sense, but compelling as prose, and more concerned with subject matter than historical reference, *ekphrasis* invites a broader and more varied audience to participate in discussions about the arts. Particularly now, as visual art becomes an increasingly important cultural touchstone, creating a series that encourages us to make meaning of what we see has become more compelling than ever. Books in the *ekphrasis* series remind us, with refreshing energy, why so many people have dedicated their lives to art.

OTHER TITLES IN THE *EKPHRASIS* SERIES

Pissing Figures 1280–2014
Jean-Claude Lebensztejn

Degas and His Model
Alice Michel

Chardin and Rembrandt
Marcel Proust

FORTHCOMING IN 2017

Summoning Pearl Harbor
Alexander Nemerov

Letters to a Young Painter
Rainer Maria Rilke

Ramblings of a Wannabe Painter
Paul Gauguin

Translated from the French
Racontars de rapin

Published by
David Zwirner Books
529 West 20th Street, 2nd Floor
New York, New York 10011
+ 1 212 727 2070
davidzwirnerbooks.com

Editors: Donatien Grau,
Lucas Zwirner
Translator: Donatien Grau
Project Assistant: Molly Stein
Proofreaders: Anna Drozda,
Jessica Loudis

Design: Michael Dyer / Remake
Production Manager: Jules Thomson
Printing: VeronaLibri, Verona

Typeface: Arnhem
Paper: Holmen Book Cream, 80 gsm

Publication © 2017
David Zwirner Books
First published 2016.
Second printing 2017

"The Last Words of the First Modern
Artist" © 2017 Donatien Grau
Translation © 2017 Donatien Grau

Distributed in the United States
and Canada by
ARTBOOK | D.A.P.
75 Broad Street, Suite 630
New York, New York 10004
artbook.com

Distributed outside the
United States and Canada by
Thames & Hudson, Ltd.
181A High Holborn
London WC1V 7QX
thamesandhudson.com

ISBN 978-1-941701-39-3
LCCN 2016949230

David Zwirner Books

ekphrasis